Chickens, Ducks and Geese

Madeleine Floyd

Chickens,
Ducks and Geese

Madeleine Floyd

National Trust

For Charlotte, Emma, Helen, Katie and Laurencia

Birds of a feather…
Thank you.

First published in the United Kingdom in 2012 by
National Trust Books
10 Southcombe Street, London W14 0RA

An imprint of Anova Books Company Ltd

Copyright © National Trust Books 2012
Text and images © Madeleine Floyd 2012

The moral rights of the author have been asserted.

All rights reserved. No part of this publication may be reproduced,
stored in a retrieval system, or transmitted in any form or by any
means, mechanical, photocopying, recording or otherwise, without
the prior permission of the copyright owner.

ISBN: 9781907892318

A CIP catalogue record for this book is available from
the British Library.

20 19 18 17 16 15 14 13 12
10 9 8 7 6 5 4 3 2 1

Reproduction by Mission Production Ltd, Hong Kong
Printed and bound by Toppan Leefung Printing Ltd, China
Series design by Lee-May Lim

This book can be ordered direct from the publisher at the website
www.anovabooks.com, or try your local bookshop. Also available at
National Trust shops and www.nationaltrust.org.uk/shop

Contents

Introduction

If birds are impressive, chickens, ducks and geese are comforting and rewarding. Originally, poultry was kept by the Ancient Greeks for the unpleasant pastime of cockfighting, which was thankfully later outlawed. As civilisation progressed, we began to discover the full potential of these remarkable fowl, and not just for meat and eggs – a single swan or goose feather dipped in ink became the quill, our foremost writing implement for many years. Surprisingly, however, it was not until Victorian times that cross-breeding began in earnest and poultry exhibitions started to take place, which have continued to this day.

The eternally optimistic cockerel greets each dawn as if it is his last, and his loud crow has become the signature tune of country life. Ducks and geese, while also providing meat and eggs, keep our pasture free of slugs and snails and the grass clipped, and also act as reliable and intelligent sentinels to protect our property. As if that weren't enough, certain breeds provide us with the soft, downy feathers that fill our pillows and quilts, beneath which we drift into a privileged sleep, leaving our cares behind. In my view we owe these generous birds our warm applause.

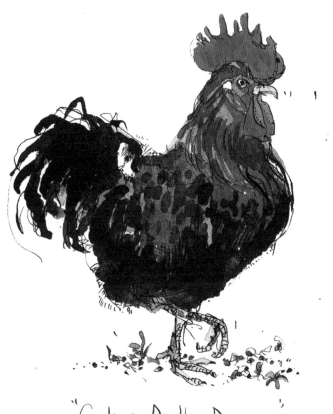

"Cock-a-Doodle-Doooo...."

Ducks, chickens, geese and swans are the feathered friends we first encounter in our childhood. I have fond memories of feeding the ducks hand in hand with my mother. These birds are a constant, waiting in the wings of our lives as we take our first trips to the park, learn how to successfully break an entry into our boiled eggs, and slowly begin to spread our wings, so to speak. We talk of 'mother hens', 'chicks', 'under our wing' and 'henpecking'; all these terms illustrate how closely we relate to these feathered fowl and have adopted references to them into our own domestic lives. As adults, our spirits are uplifted by the sight and sound of a flight of geese winging its way in formation into the distance.

I think we identify with these birds for many reasons that go far beyond our culinary appetite. We too stroll around as a species on two legs, which aligns us more closely than one might imagine. The waddling movements of chickens, ducks and geese amuse us, and they are without doubt the comedians of the bird world. We relish the parental devotion of a mother duck sitting patiently on her eggs, or taking a convoy of ducklings out for their first foray on water, and we find the clucking sounds of chickens reminiscent of our own conversation. Perhaps above all we delight in the symbiotic relationship we have with these birds.

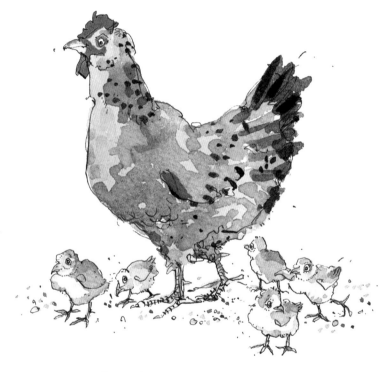

"Cluck-cluck.... Cluck-cluck....."

We supply fresh food, shelter and protection from predators, and in return we take away a basket of eggs in the morning. If only the rest of life could be this simple.

Perhaps it is this uncomplicated way of life that offers a welcome nostalgia and a refuge from the roaring commercial tide of the current world, where everything has a rising price tag and an increasing speed. There is something intrinsically satisfying about keeping chickens, ducks or geese, and I would hazard a guess that it might have something to do with offering a closer proximity to our past, a slower pace of life and a more organic and sustainable lifestyle. Keeping poultry is relatively easy and cheap, but hugely rewarding. It is paramount that we care for these birds with the respect they deserve in return. I hope this book will act as an amateur's introduction to the beautiful variety of these breeds, and a personal cheer of appreciation from a longstanding admirer.

Chapter One

Chickens

Dorking

This old-timer is thought to have been around since the Roman era. As far as we know, it was developed by crossing old Italian breeds, and it is now found across Europe and North America.

This large chicken has a generous, rectangular body with an upright comb and a wonderfully broad tail. The handsome males have large heads and impressive red wattles and combs, and – one of the distinguishing features of the breed – they strut around on short legs with five toes.

Often bred for their excellent meat, these table birds are also good layers of white-shelled, average-sized eggs. In temperament the Dorking is a docile and amenable bird, but they are not suited to small spaces, since they are naturally active foragers and enjoy having the space to roam around freely.

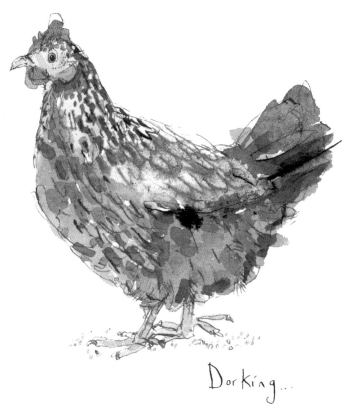

Dorking...

Wyandotte

The Wyandotte was the first breed to be developed in America, and was named after an indigenous American tribe called the Wendat. Its popularity has spread far and wide and it is now found across Europe, Australia and North America.

The Wyandotte has a small rose-coloured comb and yellow legs, and his wattle, ear lobes and eyes are red. This large, heavy, soft-feathered fowl is full-chested and curvaceous, and is available in more than a dozen colours. It has a puffed-up appearance, with a profusion of soft, downy feathers.

A calm and friendly bird, the Wyandotte hen is a superb layer, and should provide more than 200 eggs in her first laying year alone. This hardy lady can withstand cold weather, making her a great choice for the domestic garden, but attention should be taken not to over-indulge her appetite, as she puts on weight rather too easily.

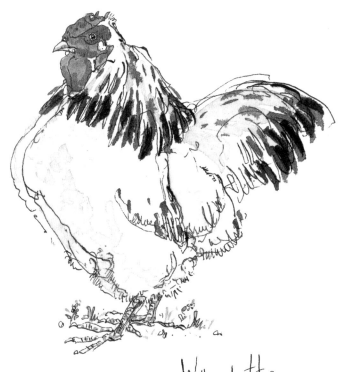

Wyandotte....

Barnevelder

This calm and friendly breed originates from the Barneveld region of Holland, and was created through the cross-breeding of local fowl with Asiatic arrivals. It was first imported to Britain in the early 1920s, and there are now bantam varieties of all the colour variants too.

With generous, broad shoulders and a full, heavy, soft-feathered body, the Barnevelder hen is a beautiful, glossy bird, with heavily inked, double-laced markings and a fine pair of bright yellow, sturdy legs. Her eggs are much loved for their rich dark brown-coloured shells.

Robust and yet easily tamed, the Barnevelder makes an excellent choice for a domestic keeper.

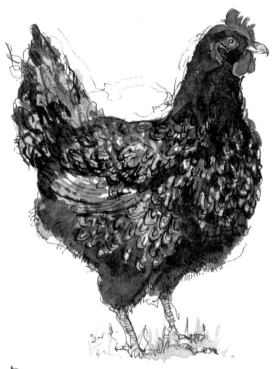

Barnevelder....

Faverolles

The Faverolles was bred in northern France in the mid-1800s by crossing the Cochin and Houdan breeds. The end result was a fowl that was supposedly both a heavy table bird and a good winter egg-layer.

The foppish Faverolles is easily recognised by its fluffy feather muffler, which looks as if it is keeping its ear lobes and wattles warm. The overall impression is one of excessive plumage and vanity; even their legs are feathered and, if you look at them carefully, you will see that beneath their furry trousers they stand on five toes on each foot.

These fancy fowl are prone to gaining weight if they are not encouraged to exercise, and they sometimes fall victim to bullying from other breeds. But – if one keeps an eye on them – they are popular and docile chickens that are easy to handle.

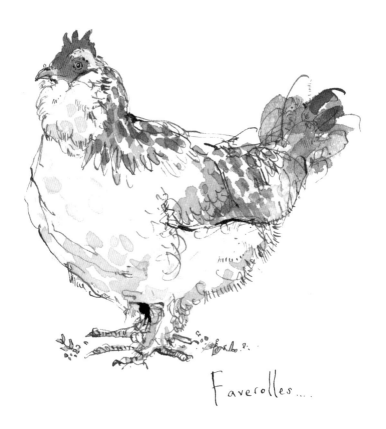

Faverolles...

Maran

Named after the French village of Marans, where it was bred, this attractive breed was first exported to Britain in the 1920s.

This large, heavy, hard-feathered bird comes in a number of plumage colours, the most well-known being the Cuckoo variety. The male has a wide, robust body, with a single upright serrated comb and elongated wattles hanging beneath a light-coloured beak.

The Maran is a natural forager and likes to rummage about in a large free-range space. In return, Maran hens are hardy and will provide beautiful, rich brown eggs. Their active nature occasionally makes them prone to bullying behaviour, but the Maran is mostly an amenable, popular and handsome choice.

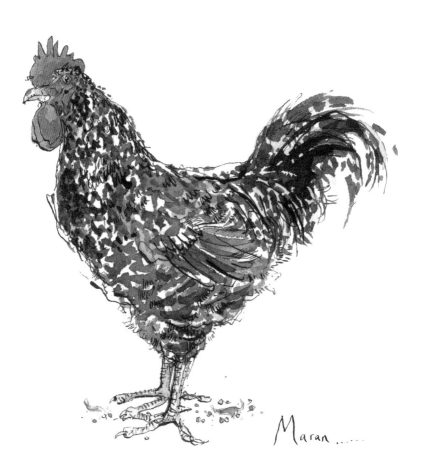

Maran......

Old English Game

This ancient breed was first documented back in Roman times. The reason they made their way into the official record seems to be their involvement in the cruel sport of cockfighting, a practice that was eventually banned in 1849.

A haughty-looking breed, the Old English Game chicken has a long neck and stands tall on long, strong legs. They can be bred in a number of colours, including Blue, Cuckoo, Partridge and Splash. Known for its aggressive air, the Old English Game is not well suited to mixed flocks and prefers good open space within which it can forage and make as much noise as it likes.

The Old English Game, contrary to what one might expect, has a tender side too. The hens are conscientious mothers, and the males are sometimes found to be closely involved in the rearing of their chicks.

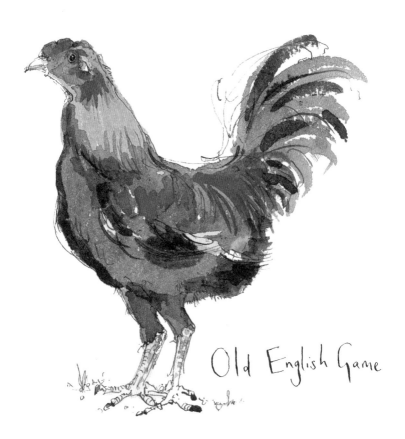

Old English Game

Sussex

Known to be both a good table bird and a reliable layer, this soft-feathered, heavy bird was first recorded in Britain in the early nineteenth century, and has become a much-loved favourite both in the UK and abroad.

For many, the Sussex's looks are that of a classic farmyard chicken: a wide, flat back with broad, confident shoulders and attractive feathered hackles. His tail waves at a 45-degree angle and he has a single red serrated comb. The breed has seven standardised colours, and is very popular on the exhibition circuit.

The Sussex hen makes a devoted mother, and her offspring mature swiftly. She continues to lay throughout the winter, and is usually docile and easily befriended. She is not equipped to fly, and because of this makes an ideal domestic garden fowl.

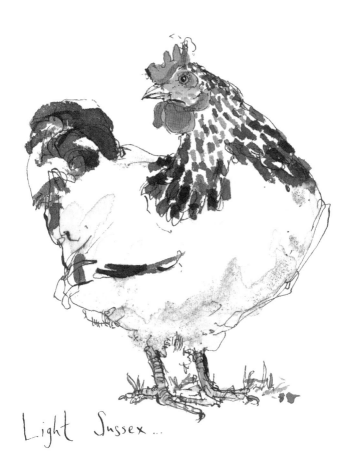

Light Sussex...

Orpington

The large, heavy, soft-feathered Orpington was originally bred in the late 1880s by William Cook, and named after his home town in Kent. The breed has been relentlessly developed through the years, which has increased its show potential but significantly diminished its laying ability.

The Orpington is all about appearances, and she comes in a handful of colours, all of which show the fluffy plumage and petticoats that we associate with this breed – this fowl appears to be so inflated with feathers so that it is almost impossible to see its actual body shape. The result is an extremely cuddly chicken, and one that has earned many admirers.

The character of the Orpington is just as one would imagine – cuddly and placid. It is a docile yet hardy 'family' bird that will happily tolerate handling, but it does need to be protected from other breeds, who may pose a risk as potential bullies to this lovable chicken.

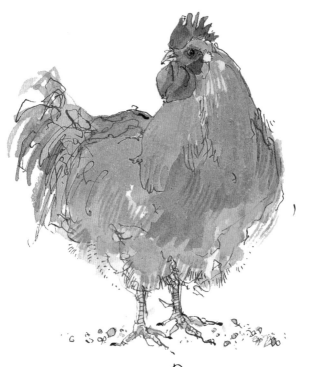

Buff Orpington

Ancona

The imperious-looking Ancona is named after the Italian port where it was developed, and was first exported to Britain in the mid-1800s.

The handsome, upright Ancona rooster has an extrovert character. He can be recognised by his clean long legs, elongated red wattle and large white ear lobes. His black-and-white plumage is often spotted, and he has a single red comb with up to seven deep serrations. Ancona hens are good layers of white eggs and rarely go broody.

The Ancona requires an experienced hand. This lively breed prefers a good amount of space and distraction – they easily become bored and rebellious if kept in confinement.

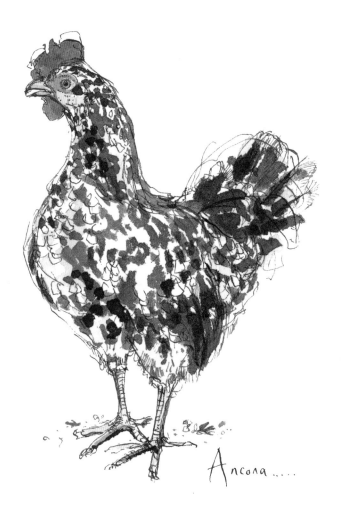

Ancona

Rhode Island Red

This composite breed was created in the USA by mixing indigenous fowl with breeds imported from the Far East, and in 1954 the Rhode Island legislature recognised the Rhode Island Red as their state bird.

The Rhode Island Red is almost rectangular when seen in profile, with a lengthy, low back on stout yellow legs and a short tail that is only slightly raised. His name is somewhat misleading; his main plumage is made up of deep chestnut browns and glossy blacks.

A good choice for the amateur, this breed is usually calm and content, and they are capable of laying up to 200 large brown eggs in a year, making it a popular domestic choice.

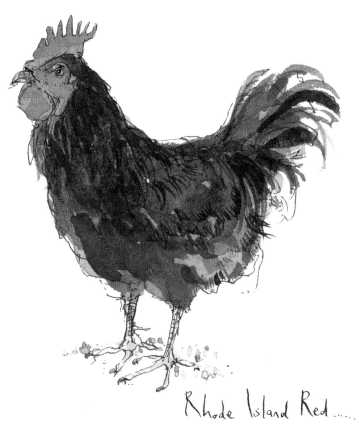

Rhode Island Red......

Welsummer

First imported from Eastern Holland to Britain in the 1920s, the Welsummer is now found all over the world. The breed seems to have been created by a mix of the Barnevelder and Rhode Island Red breeds, among others, resulting in a chicken that is hardy, easy to look after and a reliable layer.

People say that the iconic Kellogg's rooster was modelled on a Welsummer, and the males are certainly the cockerels of childhood memory. They have a long, arched back with a rounded, proud chest and a large red single comb with well-defined serrations. Their plumage contains rich browns and reds, and their generous tail feathers have a bottle-green sheen. The hens are simpler in colour, and usually speckled.

Welsummer fowl are friendly and placid. They are ideal free-rangers, enjoying a day spent foraging, and they produce the rich brown-shelled eggs that are welcome on many a breakfast table.

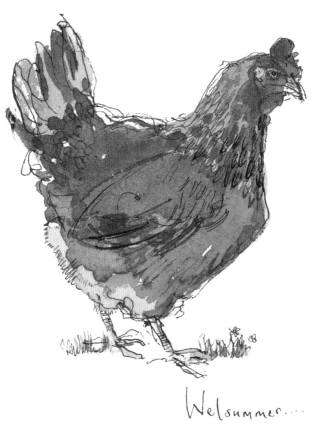

Welsummer....

Chapter Two

Bantams

Dutch Bantam

The Dutch Bantam is a true bantam, meaning that there are no larger fowl equivalents. It did not arrive in Britain until the 1960s, and some of its history remains unknown, but the accepted view is that it was bred in 17th-century Holland, with ancestry belonging in part to Indonesian jungle fowl.

This petite bantam is now available in up to thirteen different colours and is a popular exhibition bird. Characterised by an upright and alert manner, the Dutch Bantam has a small, pert head carried on a curved, shortish neck with prominent white ear lobes and a red single serrated comb. It carries its generous tail high, and the cockerels sport glossy curved-sickle feathers.

A friendly bird, the Dutch Bantam hen is a hardy one, happily surviving in small spaces and adeptly foraging by day. Even better, this popular breed lays well and produces up to 160 miniature light-coloured eggs each year.

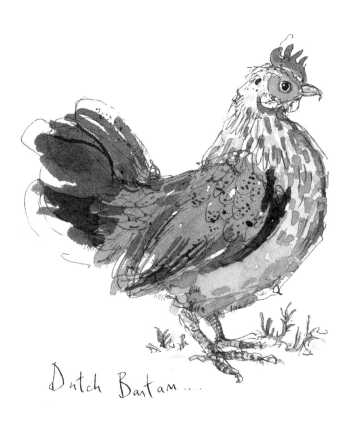

Dutch Bantam....

Sebright

Perhaps the supermodel of the bantam world, the Sebright is bred for its beautiful plumage and ornamental potential. The breed was developed two hundred years ago by Sir John Sebright, a British breeder who was also an MP.

The Sebright is renowned for her wonderfully detailed laced markings, which look as if each feather has been carefully outlined in black ink. Interestingly, the male bird is hen-feathered, that is it does not develop the curved-sickle tail feathers that cockerels usually have. Standing impressively upright on grey legs, the Sebright appears to strut confidently, perhaps only too aware of its adoring audience.

Sadly, what the Sebright hen scores in vanity, she does not possess in fertility or egg-laying ability, neither of which is very successful in this breed. A rather delicate bird, the Sebright is a specialised and engaging choice for the exhibitor rather than the amateur fancier.

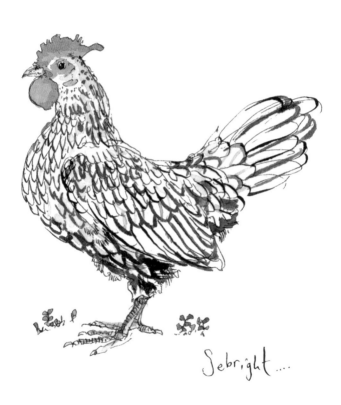

Sebright

Pekin

The Pekin arrived in Britain in 1860, supposedly transported from Peking, China (now known as Beijing) by the British army, though the breed has changed through the years to such an extent that the birds exhibited today bear very little resemblance to the first recorded Chinese Pekins.

The Pekin has a short, broad body and its head is set lower than the top of its tail, giving it an eager-looking forwards tilt. Short, feathered legs hide beneath layer upon layer of fluffy plumage, and it comes in a wide range of colours. Its overall appearance is ball-shaped and fluffy, and Pekins are commonly kept for decorative purposes.

Pekin bantams can survive happily in smaller spaces and they are usually friendly and easy to handle.

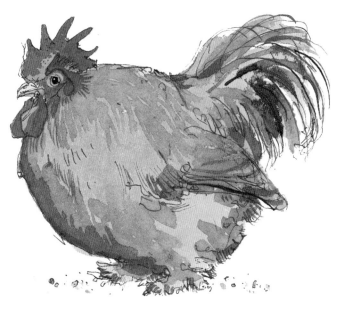

Pekin

Booted Bantam

The distinguished-looking Booted Bantam – another
true bantam – was bred in the Netherlands in the
seventeenth century.

An upright and alert bird, this bantam has a small head on a
stocky, curved neck. Its white ear lobes are prominent, and
it sports a showy vertical tail. It is bred in up to thirteen
colours, including Barred, Buff, Millefleur, Pearl Grey and
White. What sets this bantam apart from the rest are its
long, feathered feet, which are made up of lengthy quill
feathers splaying from the hock joints. A consequence of
this flamboyant footwear is that the breed should be kept in
clean, dry conditions, away from mud and dirt.

These bantams are usually friendly and docile, and they are
popular in the home garden because their feathered legs
prevent them from doing too much damage to plants. They
are also good layers, though their eggs are rather small.

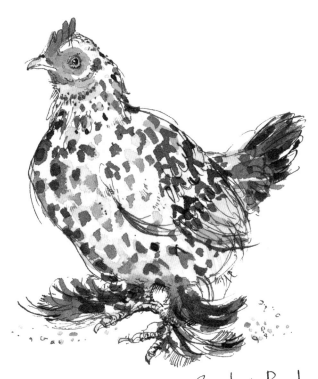

Booted Bantam...

Japanese Bantam

This tiny true bantam was first developed in Japan in the seventeenth century, but did not arrive in Europe until the late nineteenth century. Its origins are believed to be Malaysian, and this showy fellow comes in three distinct feather types: plain-feathered, silkie-feathered (with soft, generous plumage) and the frizzle, with its mass of upturned curling feathers that give an overall 'fluffed-up' appearance.

The legs of the Japanese Bantam are so petite that often they cannot be seen beneath the petticoats of this showy breed. A proud chest and upright, full and often spectacular tail feathers make for an impressive-looking bird.

In character the Japanese Bantam is active and friendly. Despite being good mothers, the breed sometimes struggles with fertility, and the eggs that are laid are cream-coloured and, unsurprisingly, tiny.

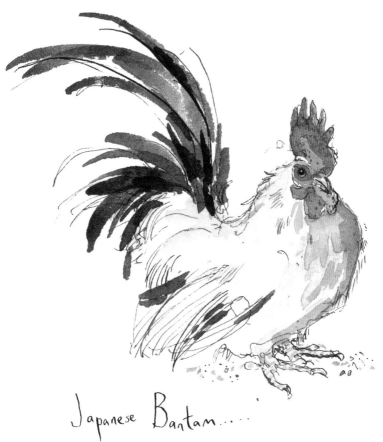

Japanese Bantam......

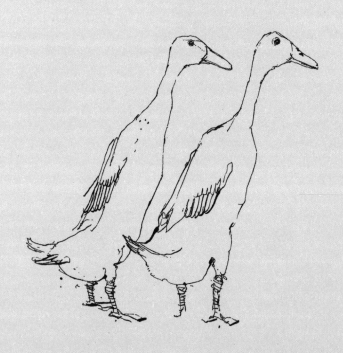

Chapter Three

Ducks

Rouen

This heavy domestic duck comes from Normandy and was imported to Britain in 1850. The Rouen's colourful plumage and generous proportions have made her a popular exhibition bird around the world.

Both the male and female have eye-catching blue patches of feathers on their wings, and the drake has a magnificent bottle-green head atop a white collar and a proud burgundy breast. Their stance is fairly horizontal, with a ponderous, low carriage.

Unlike other ducks, who on average take around eight weeks to gain their adult feathers, the Rouen takes up to twenty weeks to mature. This bird is one of the more friendly varieties of duck, and is enjoyed for its amenable demeanour.

Rouen......

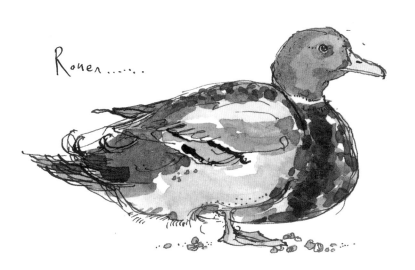

Aylesbury

The heavy Aylesbury breed was first documented in the eighteenth century, and wonderful tales exist of how these ducks were walked on foot from their home town in Buckinghamshire all the way to London to be sold at market. In later years they travelled by train, but to the same conclusion. In the 1870s the Aylesbury was crossed with the Chinese Pekin duck, and the original breed was all but lost.

The Aylesbury is the classic broad, white table bird. With a pinkish-orange bill, blue eyes and beautiful silky white plumage, this duck has an eager appetite and can reach weights of over 5kg. Because of this, she is not airborne, and needs to be watched for signs of obesity. The Aylesbury therefore requires adequate space for exercise, and preferably water for swimming, not least because their size dictates that mating is best performed on water, with the aid of buoyancy, rather than on land.

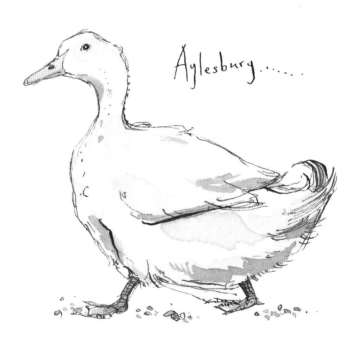

Aylesbury......

Khaki Campbell

This light domestic duck was developed by Mrs Adele Campbell in 1901. It was created by crossbreeding the Indian Runner with the Rouen, and the name Khaki was added as a mark of respect to the British army, then engaged in the Boer War in South Africa.

This handsome duck has a dusky, brownish appearance and is semi-upright in her carriage. Other colours of this breed have since been established, such as the White and Dark Campbell.

Khaki Campbells are busy, active ducks who, given the chance, love to splash around in water. They are wonderful layers and have been known to produce over 300 eggs a year, ensuring the breed's long-lasting popularity.

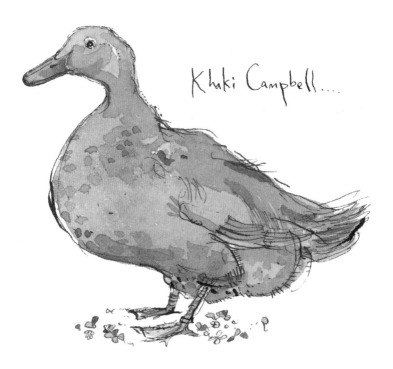

Khaki Campbell....

Silver Appleyard

The background to this British breed is not entirely clear. Reginald Appleyard was a prominent breeder of ducks and geese in the mid-twentieth century, though there is no record of when or how the Silver Appleyard was introduced, nor was the breed standardised in his lifetime. It was only in 2000 that the Silver Appleyard was finally officially recognised, following the work of Tom Bartlett in striving to reproduce this attractive breed of heavy domestic duck.

The Silver Appleyard is sturdy and rounded, with pretty colouring and flecked, fringed feathers. Standing half upright on orange legs, she wears silver petticoats that no doubt contributed to her name.

This breed of duck is a keen and active forager of insects, and has a calm attitude to life. She is a good layer of up to 180 eggs a year, which makes her a good table bird and a regular at exhibition.

Silver Appleyard

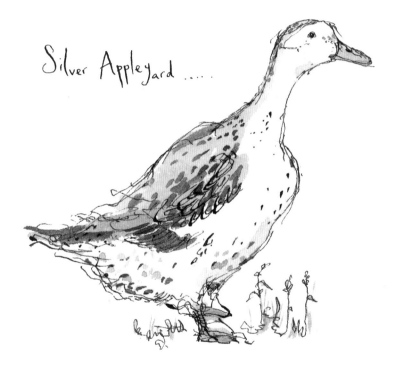

Indian Runner

The much loved Indian Runner duck originated in Indonesia, and 2000-year-old stone carvings of these birds have been unearthed in Java. They were first imported to Britain in the early nineteenth century by the Earl of Derby, and their unique upright stance meant they were initially nicknamed 'Penguin Ducks'.

Available in up to fourteen colours, the Indian Runner has a bottle-shaped body, with a long, slender neck, a svelte physique and straight, upright legs.

Like the Campbells, the Indian Runner is a wonderful layer. But the breed is not a maternal one, and the female duck will often lay her eggs out in the open and then forget about them. The drakes are also not the most responsible fathers, and if kept in large groups their over-amorous intentions can become troublesome and threatening to their female counterparts.

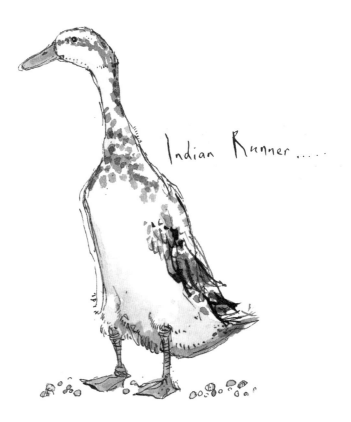

Indian Runner.....

Bali

This crested runner duck was imported into Britain from the Indonesian island of Bali in the 1920s. It is believed to have been in existence for over 2000 years, and many say that it was the ancestor of the Indian Runner. In Indonesia this duck's foraging ability comes in very handy for rice-growers: flocks of Bali ducks are led into the paddy fields, where they rid the crops of insects and pests.

The Bali duck looks very much like the Indian Runner, with the addition of a small, spherical crest on the back of its crown. In fact, it is much heavier than the Indian Runner, but is just as attractive, with clear blue eyes and usually white feathers, strutting around with an erect carriage.

This bird is not a good aviator, but can lay up to 200 blueish-green or white eggs a year, making it a rewarding and impressive duck to keep.

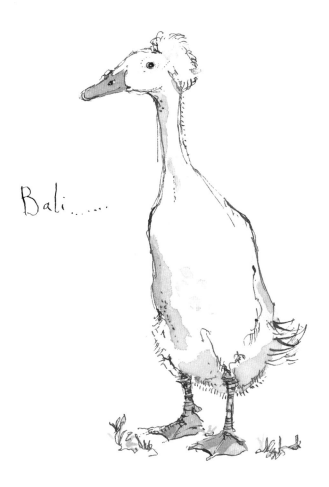

Bali......

Magpie

The Magpie duck is the heaviest of the light domestic breeds. It was initially developed by Oliver Drake and the Reverend Gower Williams in West Wales, and was standardised in Britain in 1926. This breed has fluctuated in popularity, perhaps because it is very difficult to replicate the exact markings that distinguish a successful Magpie duck for exhibition.

The Magpie has a white body and chest, with strong black markings on her back, rump and tail feathers. More obvious is the black cap, which, amusingly, becomes speckled with white as the duck ages. The yellow bill also changes colour with maturity, from yellow to green.

The Magpie can expect to lay up to 200 eggs a year, and is an all-round hardy and general purpose breed.

Magpie

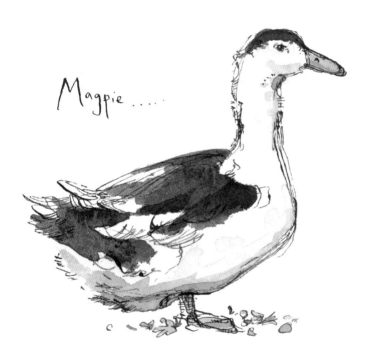

Muscovy

This specialist heavy breed was first discovered by the
Spaniards in Central and South America in the sixteenth
century. Unlike most other domestic breeds, the Muscovy is
not a descendant of the Mallard.

Very distinct in appearance, the Muscovy drake has red
caruncles (fleshy lumps) on his face, and he is much larger
than his mate.

Muscovy ducks can be quarrelsome and independent,
and are equipped with sharp claws for perching –
something they are still prone to do, setting them apart
from other ducks. Perhaps surprisingly, the female
Muscovy is one of the best duck mothers, and has been
known to sit on her eggs for over five weeks, a markedly
longer time than other breeds. She will then happily raise
her own brood to maturity.

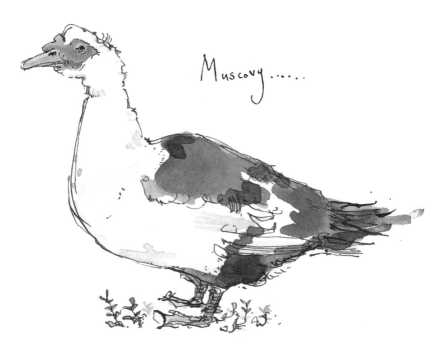

Muscovy.....

Chapter Four

Geese

Roman

First imported into Britain in the early twentieth century, the Roman goose, as her name suggests, is thought to have been the original goose of Ancient Rome, which was then taken across the Alps and into the rest of Europe. She is often confused with the white Embden goose, but in fact is much smaller.

This small breed of white goose, with its buxom, stout body, is a popular table bird. She has a generous wingspan, and may need clipping to prevent her exploring further afield.

In character the Roman goose is a good all-rounder. She feeds and breeds well, and is also a reliable layer, albeit of rather petite-sized eggs.

Roman......

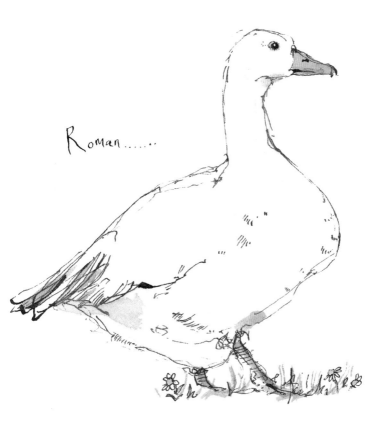

Brecon Buff

The Brecon Buff originated in Wales, bred by Rhys Llewellyn of Swansea in the 1930s, and was accepted into the British Poultry Standards in 1954.

The ideal show appearance of this hardy, medium-sized goose is hard to achieve: she must have an even shade of toffee buff across her plumage and have pink legs and feet, rather than the usual orange. The Brecon Buff was bred to be hardy, and their tight plumage allows this; they are happy to wander over rough, hilly ground, unlike many of their more pedestrian fellow geese.

The Brecon Buff is quiet and obedient, and has an almost innocent air about her. She needs space to roam and graze, but her unassuming, gentle manner makes her ideal as a domestic goose.

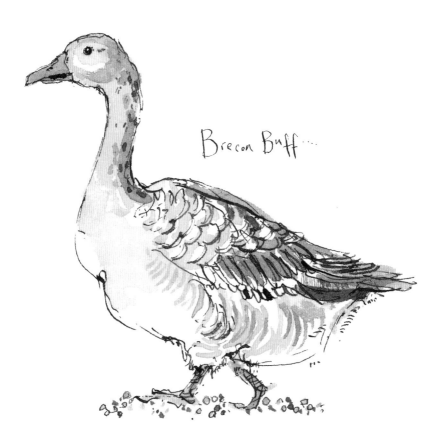

Brecon Buff....

Embden

This heavy German goose was first known as the 'Bremens' goose when it was imported to the USA in the 1820s. Nineteenth-century British farmers had already taken this large breed onto their land, and it has remained a much loved and admired variety ever since.

In appearance the Embden is the archetypal large farm goose, standing taller than many other breeds and exuding confidence and elegance.

The height and weight of this breed mean that if disturbed they can be threatening to beings smaller than themselves, such as small dogs and children. Their large size also means that an incubator can be a more successful way of rearing their young; they are prone to damaging their own eggs and goslings by clumsily sitting on them.

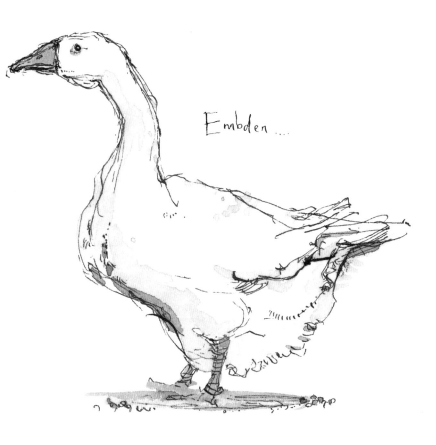

Embden ...

Pomeranian

Pomerania is an area of Northern Germany that runs close to the Baltic coast near the Polish border, and it is here that the Pomeranian goose was first bred. A utility breed, this goose is popular both for table use and as an exhibition breed.

Distinguished by its single, lobed paunch, the handsome gander has a chubby-cheeked appearance and is bred in various colours; Grey, Pied Buff, White and Pied Grey. The crown of his head is flat and he has a thick, strong neck on a long, stout body.

In temperament this breed are intelligent and impressive. They are known to be good grazers and good layers, and parent their young efficiently and successfully to maturity.

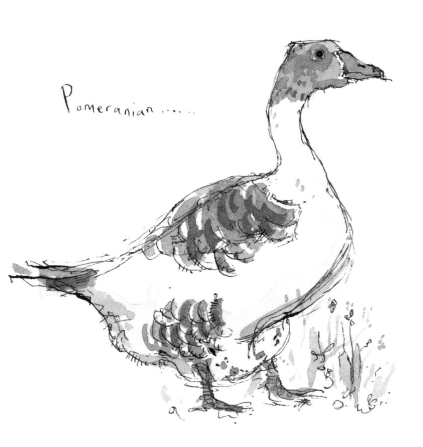

Pomeranian......

Steinbacher

Until the twentieth century, Steinbacher geese were bred in Eastern Europe and Russia, primarily to take part in goose-fighting, a sport similar to the cockfighting taking place in Britain at the same time. The Steinbacher is thought to come from a cross between the European Greylag goose and the Asiatic swan goose, and was not officially recognised in the UK until 1997.

This beautifully elegant goose is admired for her soft, greyish-blue plumage, laced with white at the tips of her feathers. Her distinguishing features include a dark black button marking on her orange bill.

Remaining true to his heritage, the Steinbacher male can be aggressive towards rival ganders during the breeding season. The geese, in contrast, are usually calm and docile, and seem to enjoy interaction with humans.

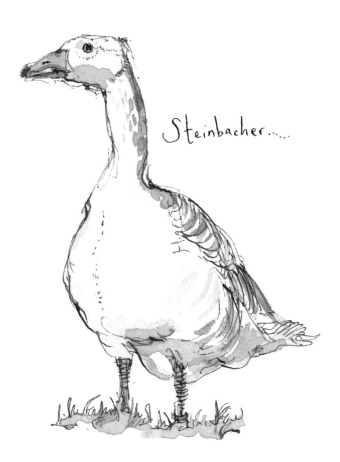

Steinbacher......

Chinese

This light breed is a descendant of the wild swan goose of Eastern Russia and China. There are many domesticated breeds of swan geese to be found in the Far East, but at the moment only the Chinese and the African goose are recognised in Britain and America.

The Chinese goose is very distinctive in appearance. Both males and females have protruding 'knobs' on their foreheads, adding a further air of majesty to their already very upright stance. They can be either pure white or a mixture of grey and buff browns, the latter including a long brown stripe that runs across the face and down its neck.

Despite their relatively small size, these geese are loud and curious in character, and for this reason are often kept in place of guard dogs. In addition to these qualities, the Chinese goose is also a successful layer, and will happily go broody if required.

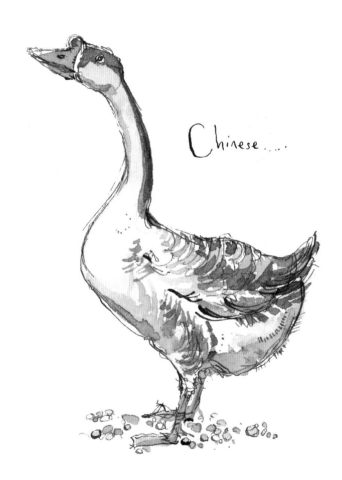

Chinese....

Pilgrim

Many believe that the Pilgrim goose originally came from Britain, but its early history is largely unknown. These geese were standardised in the USA in 1930 following the work of Oscar Grow, who named the breed in homage to his family's own pilgrimage from Iowa to Missouri during the Depression.

Pilgrim geese are rare in that they are one of only two auto-sexing breeds; that is, males and females can be differentiated as goslings by their colour and markings. The gander is white with blue eyes, and the female goose is soft grey, with white 'spectacles' around her brown eyes. The ganders are slightly larger and more assertive, but the females have a louder calling voice.

Pilgrims make good parents. The ganders are protective of their geese, and in turn the geese are considerate and light-footed around their eggs and goslings. As a result this breed is a popular and rewarding choice to keep.

Pilgrim

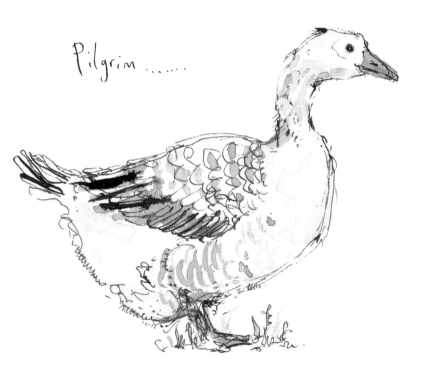

Toulouse

The Toulouse was originally bred in southern France
for pâté de foie gras. The Earl of Derby first imported the
breed to Britain in the 1840s, and a decade later they
arrived in the USA.

The Toulouse is one of the heaviest geese, often weighing in
at over 13kg. It has a large head, with a pendulous dewlap
that swings beneath its bill and a feathered keel in front of
its chestbone. Its body often appears even larger than it
actually is, because of its very open and full plumage. The
nature of their plumage means that the geese need to be
given good dry shelter, as they are vulnerable to cold and
wet in winter, and to insects in summer.

This stately goose is a gentle giant by nature, moving at a
leisurely pace and seeming shy at times. She is a reasonable
layer, but is more often kept for exhibition than breeding.

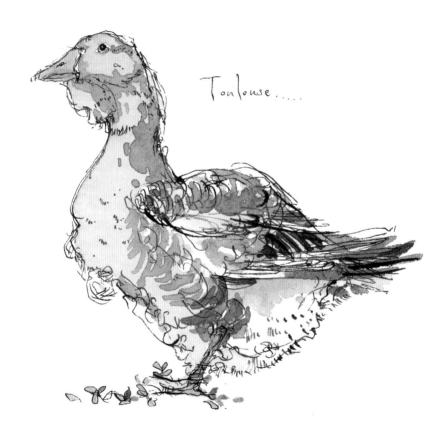

Toulouse.....

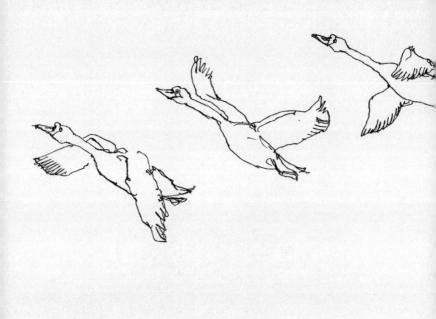

Chapter Five
Swans

Bewick Swan *Cygnus columbianus*

The wild Bewick swan breeds in Arctic Siberia but wisely migrates to Western Europe before winter sets in. This handsome bird is named after the British engraver Thomas Bewick, and is the smallest of the swans.

Despite a huge wingspan of up to seven feet, the Bewick is a stocky fellow, with a relatively short neck in comparison with his more elegant contemporaries, the Mute Swan and the Whooper. The Bewick is never at a loss to be heard, and gives out a loud, chatty chorus of high-pitched honkings when socialising in large flocks of other Bewicks.

The female (pen) builds her nest by herself, gathering lichen, moss and soft featherdown to make a lining. She usually lays three or four eggs towards the end of June. The male (cob) then takes up his role as security guard, keeping a protective watch over his mate while she incubates the eggs for a further 38 days.

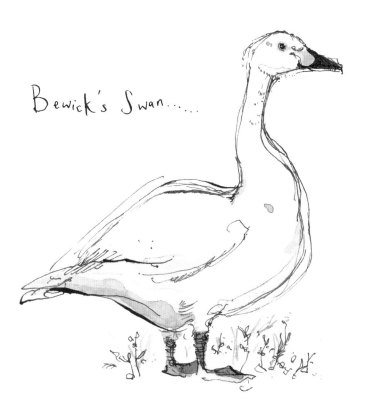

Bewick's Swan......

Mute Swan *Cygnus olor*

This elegant bird can be found all over Britain and Europe. In the Middle Ages, Mute Swans were often captured for the table, but luckily this is no longer the case, and we all share memories of admiring these majestic swans gliding along the lakes and rivers of our childhood.

This swan's name is misleading; the Mute Swan can be vocally aggressive if threatened, and they beat their wings to ward off intruders. They mate for life, and the female builds a huge nest among reeds and rushes. Her cygnets have a grey-brown plumage that slowly becomes patchy white before the mature swan emerges with its pristine white feathers.

The Mute Swan is perhaps at his most impressive in flight. To achieve take-off, he runs hard across the water's surface for up to 100 metres, flapping his wings hard to gain the momentum to take to the skies, and in that instant give the unforgettable impression of weightless ease.

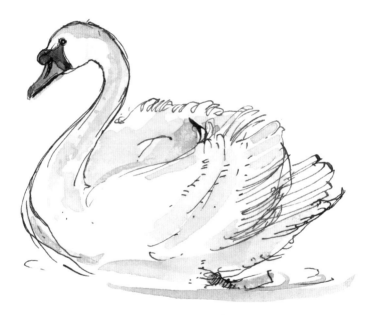

Mute Swan.....

Chapter Six

Wild Geese

Canada Goose *Branta canadensis*

Canada geese were originally imported to Britain from North America in the seventeenth century, commissioned by Charles II to decorate the lakes in St James's Park. Since then they have become commonplace in our urban landscape, and are widely seen in many town parks as well as in the countryside. The breed has now all but lost its migratory instinct.

Standing tall on black legs with their noticeable ebony neck, head and white chinstrap, these geese often have a wingspan of up to 2.13m (7 ft). The largest species of wild goose, Canada geese sometimes live for over 20 years.

Canada goslings are able to fly at nine weeks, but this breed has strong family values: they stay with their parents right through the winter until the following spring, when they assert their independence and leave home.

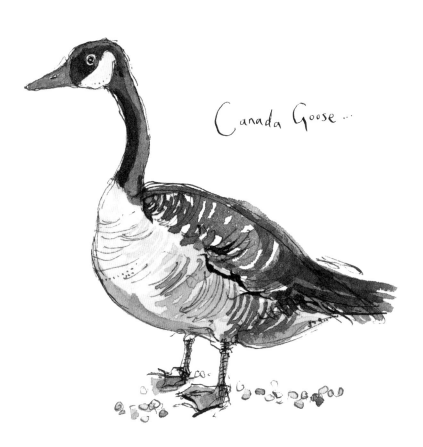

Canada Goose...

Pink-footed Goose
Anser brachyrhynchus

The migratory Pink-footed Goose breeds in Greenland, Iceland and Svalbard in Norway, but, wisely, winters in the Low Countries and Britain, where it can be found on large estuaries, in particular on the eastern Scottish and Norfolk coasts.

This is a sociable goose who enjoys the company of other geese. They feed noisily in large flocks, and have been described as the most musical variety of goose, perhaps because of their slightly higher-pitched tone.

Their other calling card is the way in which they often 'whiffle' on approaching touchdown; they appear to tumble vertically, as if out of control, spinning and flapping – until they land effortlessly on the ground and brush themselves off swiftly, as if to prove to the bystander that such a dramatic descent was always intentional.

Pink-footed Goose

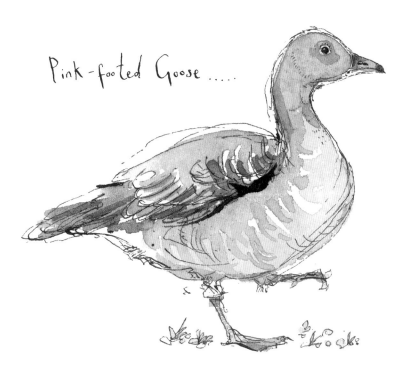

Barnacle Goose *Branta leucopsis*

Legend has it that the name of this goose comes from
a 12th-century Irish belief that its embryos were to be found
in barnacles clinging to floating timber. The idea of a goose
hatching from a seashell seems absurd, but it is said that
this far-fetched idea was not wholly disproved until the
early 19th century.

The Barnacle Goose breeds on the Arctic islands of
Spitsbergen and Greenland, and winters in Britain. He is
noisy, and his call sounds almost argumentative in tone.
Unlike many other wild geese, Barnacles fly in irregular,
haphazardly shaped flocks rather than in formation.

The Barnacle Goose often makes her nest amid
mountainous rocks, beyond the reach of predators. This
habitat is treacherous for her young, who must quickly learn
how to navigate their way to feeding grounds without losing
their footing and falling to their deaths.

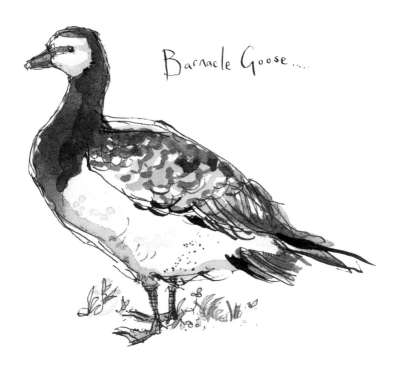

Barnacle Goose....

Greylag Goose *Anser anser*

An ancestor of the domestic goose, the Greylag Goose has over many years gradually become almost tame, and usually remains resident to Britain. In the past this breed was considered a symbol of fertility. It is widely accepted that the 'lag' part of the name derives from its rather slow speed of flight, which leaves them tailing behind the other breeds of goose in the skies.

This large, orange-billed and pink-legged goose breeds widely across Europe, and can often be heard honking her loud call as she flies overhead in her V-shaped flock. These geese are known to mate for life, and after any separation from each other, the happy couple can be seen reuniting with a ritual of posturing and raucous calling, in imitation of their initial courting days.

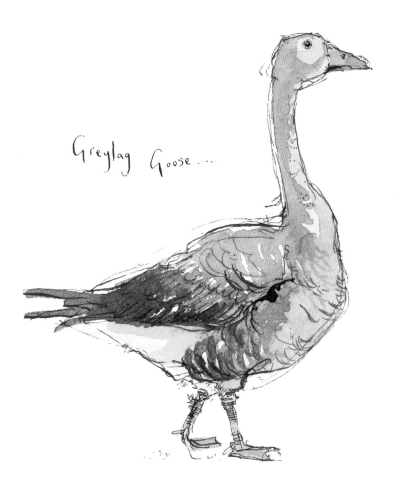

Greylag Goose.....

Chapter Seven
Wild Ducks

Mallard *Anas platyrhynchos*

The much-loved Mallard is the duck of our childhood visits
to the park, and that great British institution of 'feeding the
ducks'. Similarly, it is the female Mallard whose 'quack-
quack' call has now become the quintessential 'duck voice'.

This breed of duck nests throughout Europe and is mainly
resident. The drake is a handsome fellow, with his proud
yellow bill, bottle-green head, clerical white collar and
burgundy chest. Their bright orange legs are set far apart
and to the back of their curvaceously heavy body, a position
that encourages their amusing waddling walk on their wide
webbed feet.

These ducks feed on seeds, aquatic insects and grain –
that is, when they are not being fed on the contents of
our bread bins!

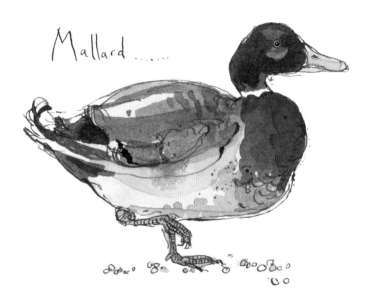

Mallard

Garganey *Anas querquedula*

The mottled brown Garganey duck winters in tropical
Africa and migrates to the Mediterranean in spring. It is
usually spotted in Britain during the autumn, making
surprise appearances among flocks of other ducks such
as Shovelers and Teal.

This stoutly handsome duck is a shy fellow, with a
mechanical-sounding, rattling call, and his preference for
grassy wetlands and marshy meadow banks makes him a
rare, difficult-to-spot breed. In courtship the drake swims in
circles around his mate and tosses his head up and down,
sometimes arching himself backwards in an attempt to win
affection. Small groups of drakes take to the air and offer
low-flying display flights, skimming the surface of the water
to further impress their mates.

In flight the Garganey is one of the fastest ducks, able to
reach a full speed of around 60 miles an hour.

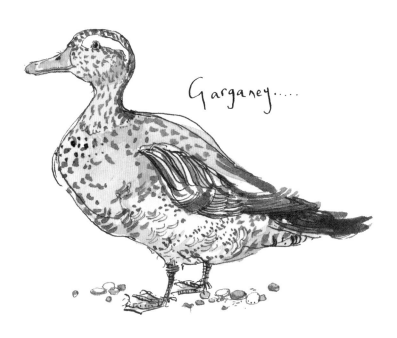

Garganey.....

Teal *Anas crecca*

The small but agile Teal is understandably wary of man,
having for many years been a shooting target. Its airborne
agility is noticeable: when startled, the teal takes off with a
sudden, almost vertical ascent. Once aloft, its rapid wing-
beats and great speed, which exceeds that of many other
duck species, make it an elusive and difficult target.

This small dabbling duck is common throughout Britain,
both inland and on coastal water. They congregate in small
groups and feed in shallow water, on seeds and small insects.
The females are a mottled brown, while the drake wears a
yellow-edged, dark green eye mask reminiscent of an
18th-century highwayman.

The shy female Teal builds her well-camouflaged nest
among tall grasses or beneath low-hanging vegetation,
and not even her partner is allowed to visit as she
incubates her brood of eggs.

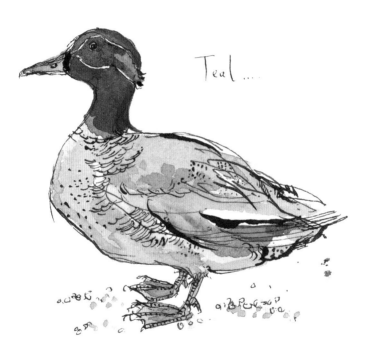

Teal....

Pintail *Anas acuta*

The Pintail duck breeds mainly in north-eastern Europe, travelling to Britain for the winter. This elegant but shy duck is relatively rare and often hard to identify, preferring to keep to itself in small groups or isolated pairings. This elusive breed chooses to move its nesting site every couple of years, and as a result of this, species numbers are difficult to quantify.

The Pintail has a toffee-brown-coloured head and a straight grey bill, with impressive elongated black tail feathers. When seen in flight, often in a 'V' formation, these long tail feathers set this breed apart, and in courtship the drakes raise their long tails upwards to embellish their flirting display.

The male Pintail has a low, muted, whistling voice and the female communicates with a gentle 'quack'.

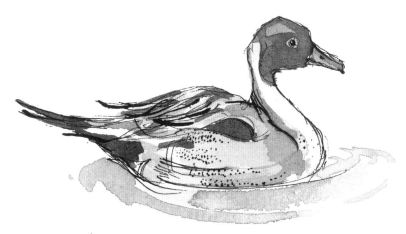

Pintail......

Eider *Somateria mollissima*

The striking and sociable Eider duck breeds in large colonies of up to a thousand pairs, often in remarkably exposed sites. In winter, large, active flocks can usually be found along the coastline of Western Europe and on the North and Baltic seas.

The Eider drake is an unusual-looking, heavy bird with a straight, triangular bill and a black eye mask, which contrasts arrestingly with his white chest and back feathers.

The female Eider is famous for the insulating qualities of her down feathers, and duck farmers carefully collect her down to sell for use in eiderdowns and other bedding. Eider ducks also use this asset in their nests, placing a generous layer of down on top of their brood of eggs to keep them warm and protected from the elements.

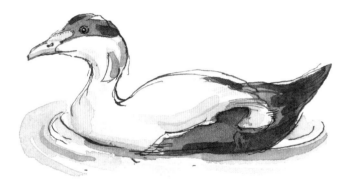

Eider......

Pochard *Aythya ferina*

The handsome Pochard is an inland diving duck that is widespread across eastern, central and north-western Europe, and a regular autumn and winter visitor to Britain. He is most commonly seen alongside other tufted ducks, and prefers to nest among reed beds and grassy vegetation.

In keeping with his fellow divers, the Pochard 'upends' in order to collect food from below the water's surface. He enjoys eating all sorts of seeds, roots and submerged leaves and plants. He begins each dive with a comical short jump upwards, before descending impressively underwater.

The Pochard can be recognised by his steep, sloping profile and rich russet head. He sports a soft grey overcoat, and has a proud, glossy brown chest.

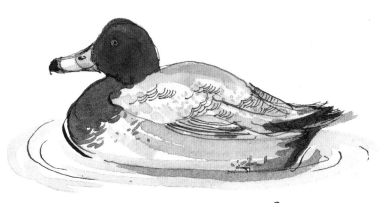

Pochard....

Shelduck *Tadorna tadorna*

The migratory Shelduck can be found along the coast of
Europe, preferring sandy and muddy shores, but can also be
seen sometimes on lakes and reservoirs. The name Shelduck
comes from the Dutch word for 'variegated', an obvious
description of the bold markings of this hefty duck.

This large, almost goose-sized duck flies to the Heligoland
Bight off the coast of Germany towards the end of summer,
where it moults its entire plumage before returning in
autumn. The drake is recognisable for his bright red bill,
which has a bulbous swelling on its top edge.

Unlike other ducks, the Shelduck builds her nest in holes
in the ground, and has been known to use disused rabbit
burrows to provide a safe, undisturbed nursery for her
offspring. Once her ducklings are hatched, the Shelducks
operate a system of crèche childcare, often sharing the
responsibility for their young among neighbouring
adults, so it is not uncommon to see a hundred ducklings
being chaperoned by one couple as they take to the water
for early swimming instruction.

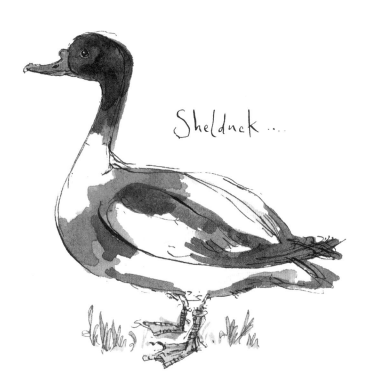

Shelduck ...

Long-tailed Duck *Clangula hyemalis*

This elegant breed of marine duck breeds largely in Iceland and Scandinavia, usually arriving on British shores in September and departing again in early May. They are usually seen in the north, favouring the coast of northern Scotland and the islands of Shetland and Orkney.

A friendly breed, Long-tailed Ducks raise their young in large, communal flocks, and these petite birds appear to be quite comfortable even on relatively rough tidal water, bobbing along the breaking waves with the greatest of ease.

As their name suggests, this duck is notable for its elongated tail feathers, which are often held bolt upright, particularly when the drake is in the midst of his courtship display. The drake also has a pleasantly tuneful call with a yodelling quality and a surprisingly wide repertoire.

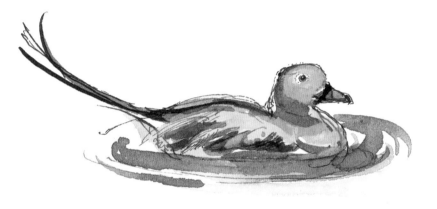

Long-tailed Duck

Mandarin *Aix galericulata*

This flamboyant show-stopper originates from China, was introduced to Britain in the mid-eighteenth century, and can now be found across England and southern Scotland. The Mandarin prefers to live around lakes with surrounding woodland or dense shrubbery. Unlike others, this breed likes to perch in low-hanging trees, and they often build their nests in vacant tree holes, from which later on their young will take their inaugural dive into the water below.

The Mandarin drake is quiet and unassuming, but unmistakable because of his splendid plumage. He has long, wispy, russet-coloured whiskers and triangular orange sails on his back, and his chest feathers are aubergine and emerald green. After moulting he resembles the more dowdy female, but both have the same bright white stripe above their eyes.

In Japanese and Chinese history this duck has been celebrated as a symbol of beauty and fidelity: it is believed that they pair for life.

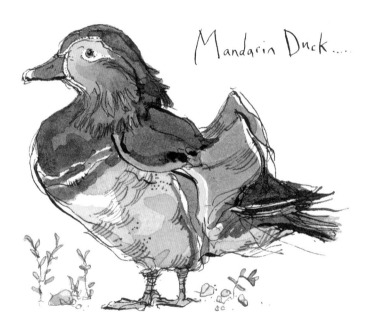

Mandarin Duck.....

Scaup *Aythya marila*

This small diving duck is an autumn and winter visitor to Britain, breeding largely in northern Scandinavia and along the Baltic coast. A handful of pairs breed in Britain each year, and these are closely protected and admired. The name 'Scaup' derives from a medieval term for a mussel bed, and is still apt for this fellow, who shows a strong taste for mussels in his diet.

The Scaup closely resembles the Tufted Duck, making him a difficult species to spot. But when seen up close, the Scaup has a distinctive bottle-green tint to his dark head, and both males and females show broad white markings along their wings in flight.

The Scaup female builds her nest on dry land near the water's edge, and lays up to a dozen eggs. The young are raised in large colonies, which can sometimes be seen feeding at sea in large but seemingly sedate flocks.

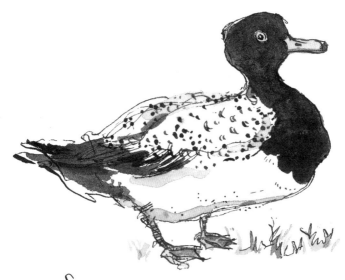

Scaup....

Tufted Duck *Aythya fuligula*

The friendly Tufted Duck was originally native to northern and north-eastern Europe, but has now spread widely across western and central areas of the continent, making its home on both stagnant and freshwater lakes, reservoirs, urban ponds and coastal water.

Suitably named, the yellow-eyed male Tufted Duck has a wispy crop of feathers at the back of his head and a striking monochrome body, with a black coat and white waistcoat. The female is a more muted version of this, with brown feathering and no white flanks.

The Tufted Duck is one of the best diving ducks, and, despite being a little cumbersome on land, can be seen adeptly diving to a depth of three metres (10 feet) to find a tasty meal of molluscs and small fish. Gregarious in nature, this breed gathers in large flocks and enjoys the company both of its own breed and others.

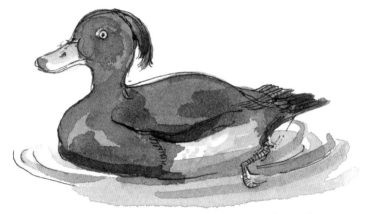

Tufted Duck.....

Ruddy Duck *Oxyura jamaicensis*

Ruddy Ducks were first introduced at the Wildfowl and Wetlands Trust at Slimbridge, Gloucestershire, in 1948. The new arrivals quickly made themselves at home, and before long had escaped their confines and were making themselves more widely known across the UK. This handsome duck causes concern for conservationists, since it mates with endangered duck species.

The drake is easily distinguished by his almost neon-bright blue bill, which noticeably contrasts with his chocolate-brown body, black caped hood and white cheeks. His tail feathers are long, and in courtship he slaps his bill against his chest, creating a rattling sound and producing a frothy pool of bubbles in the water around him.

Not a duck for the skies, the Ruddy Duck is clumsy on land, and prefers to remain in the water. Nests are built among reed beds and often include a roof for rain cover.

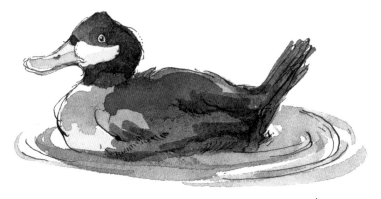

Ruddy Duck.....

Bibliography

Rare Poultry Breeds, David Scrivener
The Crowood Press Ltd, 2006

Bantams, JC Jeremy Hobson
The Crowood Press Ltd, 2005

Choosing and Keeping Chickens, Chris Graham
Hamlyn, 2006

Keeping Pet Chickens, Johannes Paul and William Windham
Interpret Publishing, 2005

Beautiful Chickens, Christie Aschwanden
Frances Lincoln Ltd, 2011

Keeping Ducks and Geese, Chris and Mike Ashton
David & Charles, 2009

Choosing and Keeping Ducks and Geese, Liz Wright
Octopus Publishing, 2008

Reader's Digest Field Guide to the Birds of Britain
Reader's Digest Association Ltd, 1981

RSPB Birds of Britain and Europe, Rob Hume
Dorling Kindersley, 2002

The Illustrated Encyclopedia of Birds
Treasure Press, 1978

Illustrated Guide to Birds of Britain & Europe
AA Publishing, 1997

Birds Britannica, Mark Cocker and Richard Mabey
Chatto & Windus, 2005

Chirp! Birdsongs of Britain and Europe (iPhone app)
iSpiny Software, 2011

www.rspb.org.uk

www.nationaltrust.org.uk

Index

The National Trust cares for over 700 miles of coastline, many of which sees Eider ducks, Canada geese and other wildfowl and waders visiting over the cold winter months. Among many others, their National Nature Reserves, such as Blakeney Point in Norfolk, the Farne Islands off the Northumberland coast and Murlough in Northern Ireland are crucial to the ongoing survival of wild ducks and geese. To plan a visit to any of the sites featured in this book, visit www.nationaltrust.org.uk.